P♥RN FOR
women
of a **Certain Age**

P♥RN ● FOR women
of a Certain Age

From the Cambridge Women's Pornography Cooperative

Photographs by Gretchen LeMaistre

CHRONICLE BOOKS

SAN FRANCISCO

A PORN FOR book.
PORN FOR is a trademark of Urgent Haircut Productions.

Library of Congress Cataloging-in-Publication Data:
Porn for women of a certain age / from the Cambridge Women's
Pornography Cooperative ; photographs by Gretchen LeMaistre.
p. cm.
Includes index.
ISBN 978-0-8118-6629-3
1. Men—Humor. 2. Middle-aged women—Humor.
3. Man-woman relationships—Humor. I. LeMaistre, Gretchen.
PN6231.M45P68 2009
817'.60803522—dc22
2008029839

Manufactured in China
Designed by Tracy Sunrize Johnson

10 9 8 7 6 5 4 3

Chronicle Books LLC
680 Second Street
San Francisco, California 94107

www.chroniclebooks.com

In our previous published studies, we at the Cambridge Women's Pornography Cooperative focused on women across the age spectrum.

But porn is not one-size-fits-all.

When women of a certain age came to us asking for a more trenchant examination of their particular desires, we rose to the challenge. Sure, the hunks in *Porn for Women, Porn for New Moms,* and *XXX Porn for Women* raised their pulses, but as women evolve, so too do their desires.

So what exactly turns on the more mature, more experienced woman?

Going into this study, we had plenty of theories. We spent weeks holed up in the lab, sorting through thickets of data; compiling stats; classifying our hypotheses; making pie charts, flow charts, bar graphs; and finally testing our theorems. Here, in this steamy treatise, we're proud to present our groundbreaking findings.

Witness the results of our research now, simply by turning these pages (actually, please pay for the book first—we at the Cambridge Women's Pornography Cooperative have laboratory overhead to cover, too).

In this revolutionary body of work, you'll enter a world where you're reminded that you look perfect, every day, just the way you are... where bathroom scales are all discovered to be reading high by ten pounds... and where throw pillows are given all the cultural import they deserve.

So sit back, turn down the lights, and let *Porn for Women of a Certain Age* steam up those progressive lenses.

Wait.

This date of birth
can't be right.

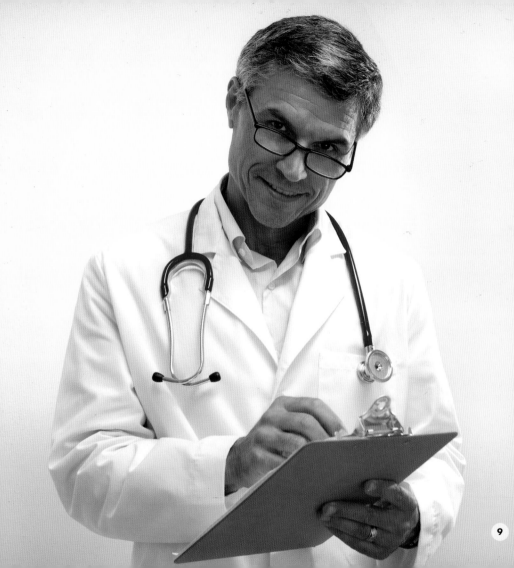

I just don't get this whole *trophy wife* thing.

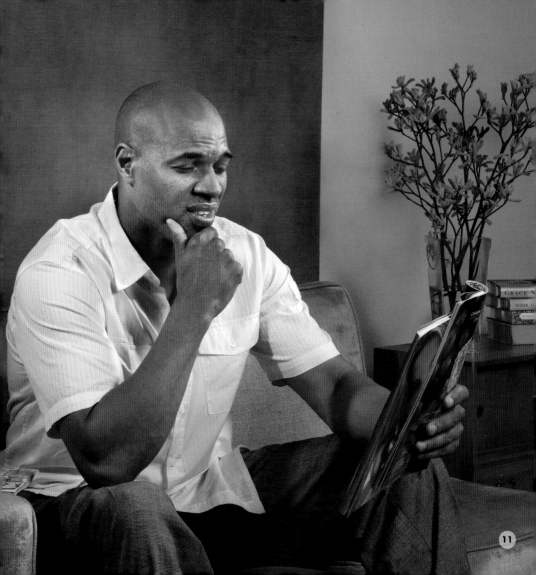

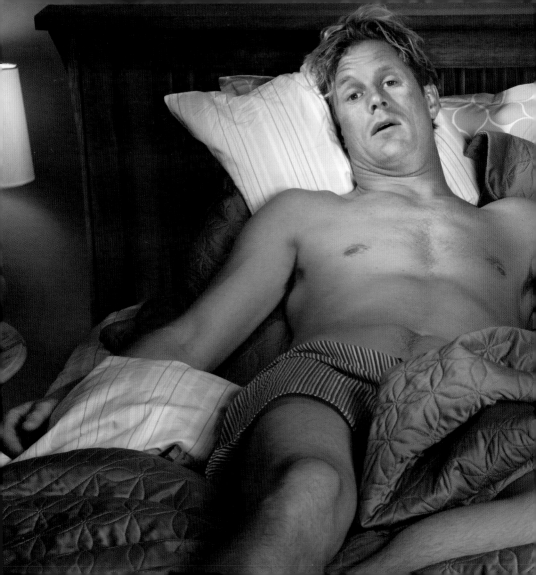

Wow. There's something to be said for a *woman with experience.*

I figure that if I *give up my football tickets,* we can buy that property in

Hawaii

this year.

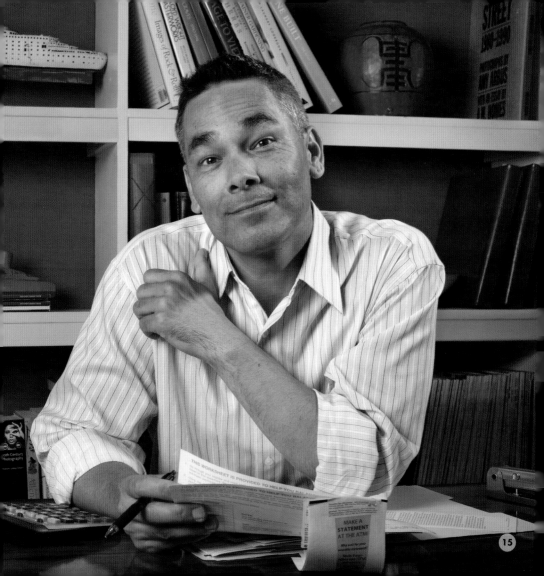

I think you look

better now

than you did
20 years ago.

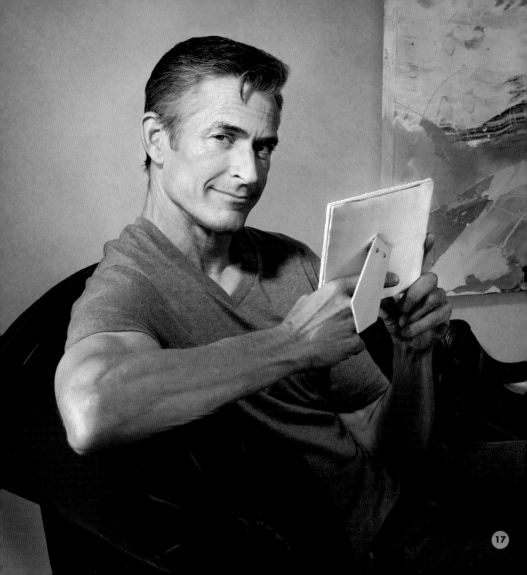

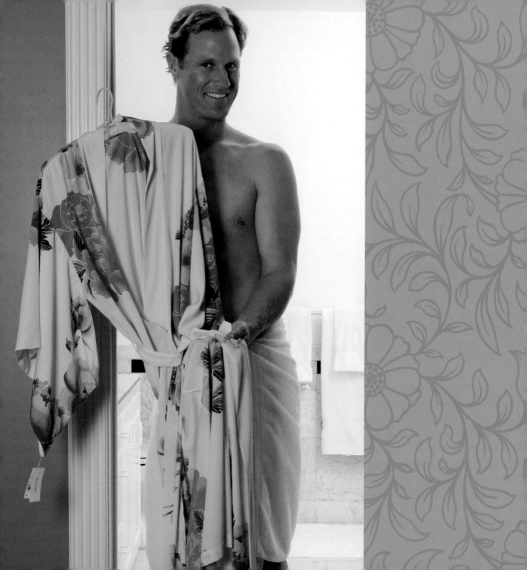

I saw you
admiring this
the other day,
so I went back
and got it for you.

Explain it to me again.

Why did all your friends
at the reunion look
so much **older** than you?

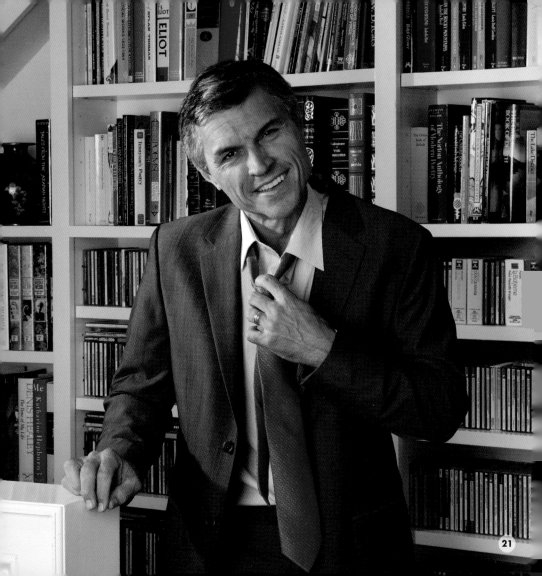

Hot flash?

Let me **fan you** for a while.

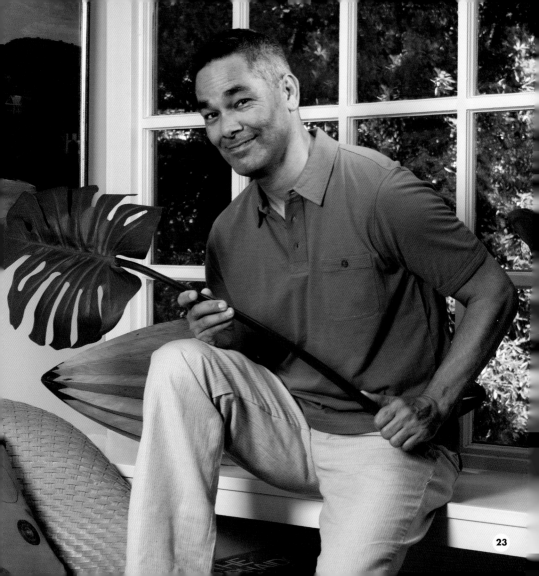

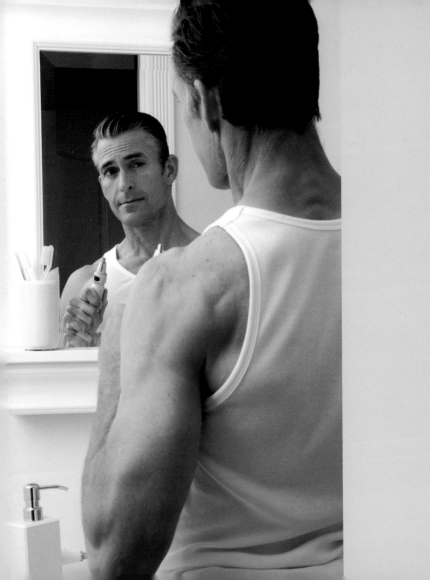

You wouldn't **believe** some of
the guys at my gym…
bushels of hair
in their noses and ears.
Can you imagine a guy
letting himself go
like that?

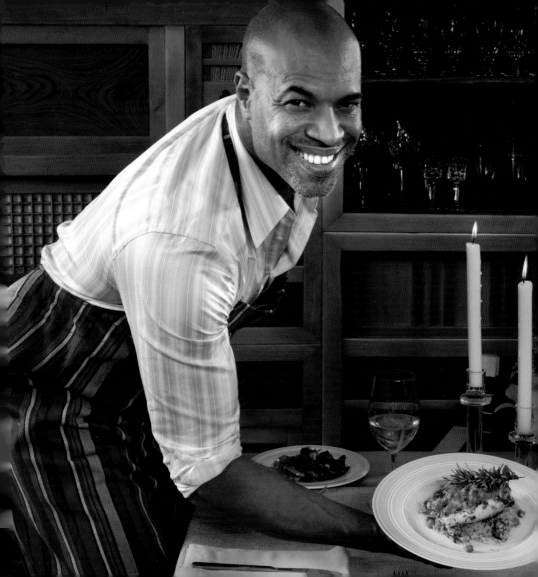

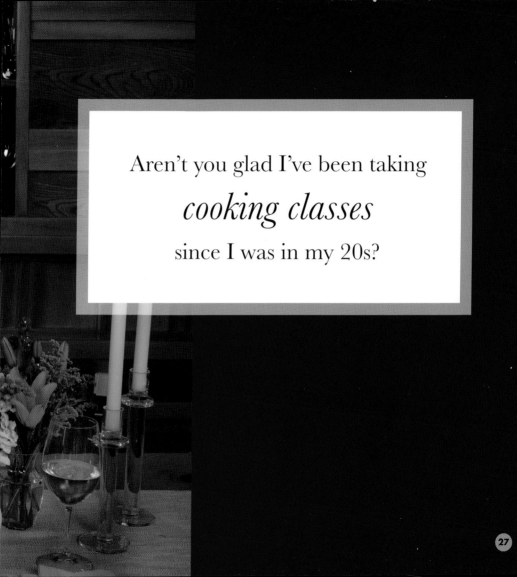

Aren't you glad I've been taking

cooking classes

since I was in my 20s?

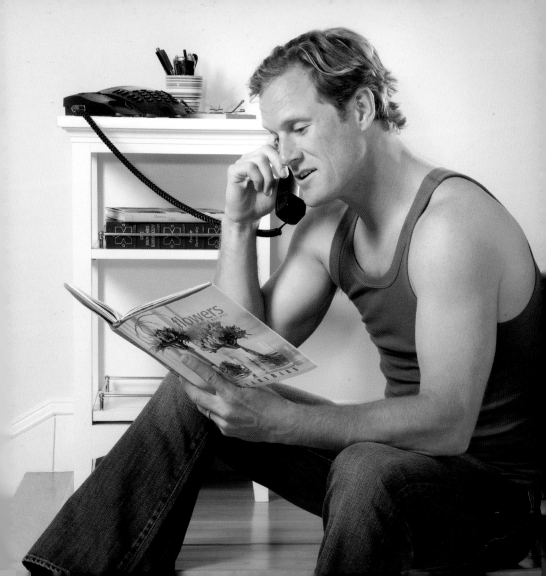

Well, fishing sounds nice, but

we *never* miss the flower show.

If it detects more than
two decibels of snoring,
it jolts me awake
and I roll over.

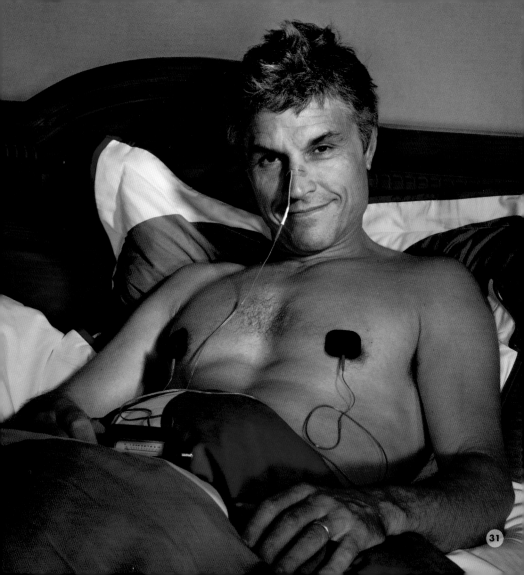

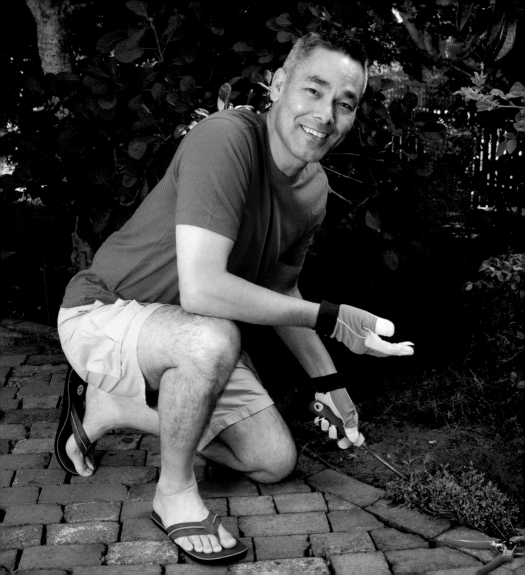

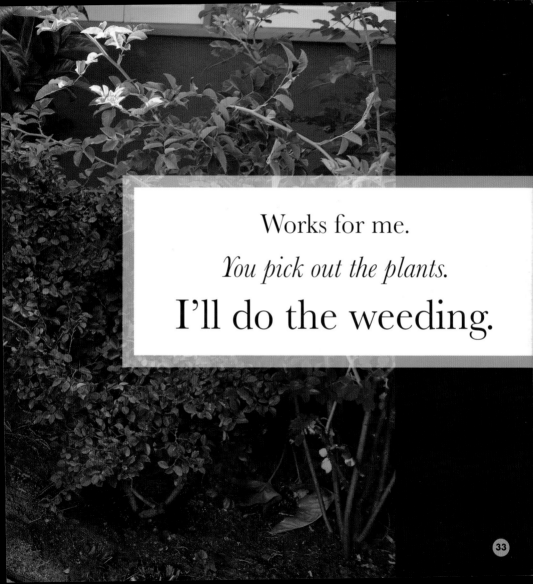

Works for me.

You pick out the plants.

I'll do the weeding.

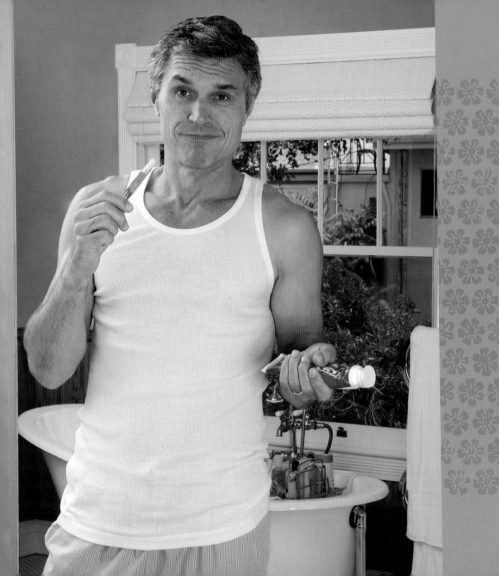

A facelift???

Don't be ridiculous.

You're perfect.

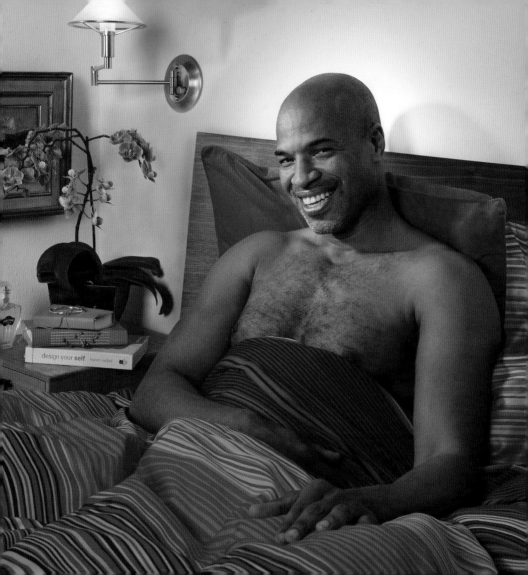

I got in a half hour early,

so your side would be

nice and toasty.

My doc says
I have the prostate
of a 29-year-old.

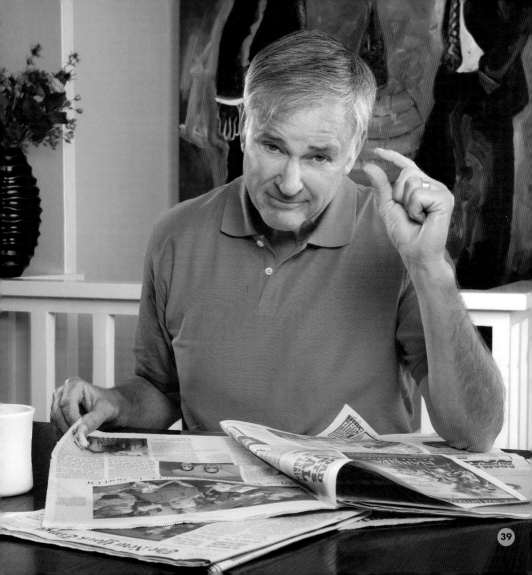

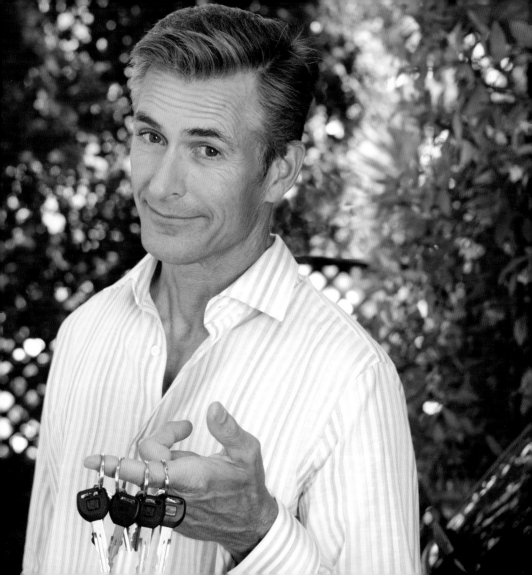

Now we'll **never** have to search for the car keys again!

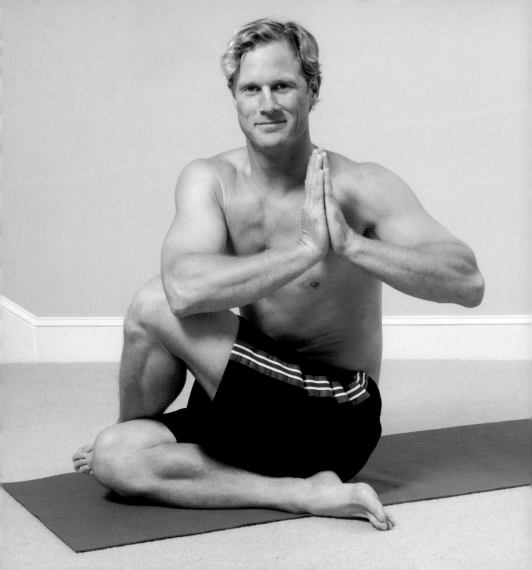

AARP, *kiss my ass!*

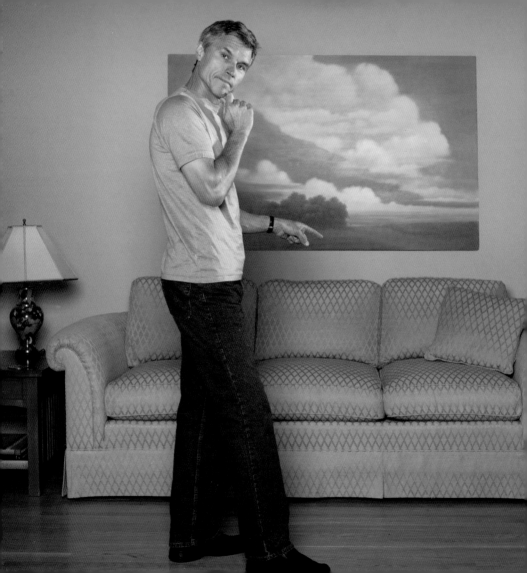

You know what this could use?
Some throw pillows.

I just want to make sure
your friends stay
a little bit **jealous** of you.

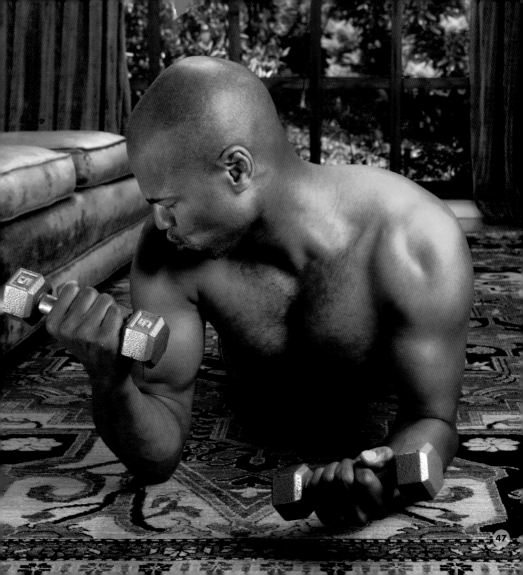

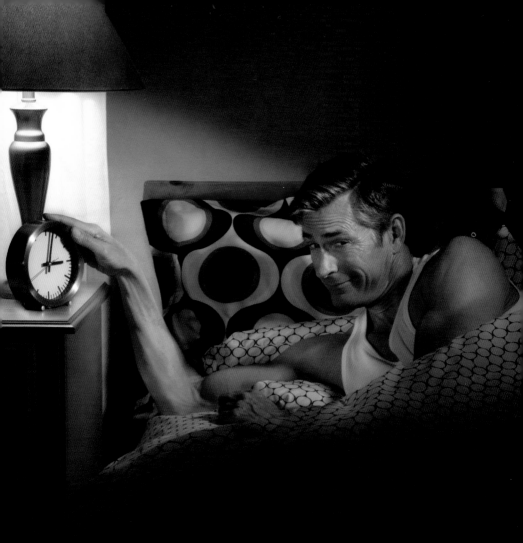

No, this is a
good time to talk.

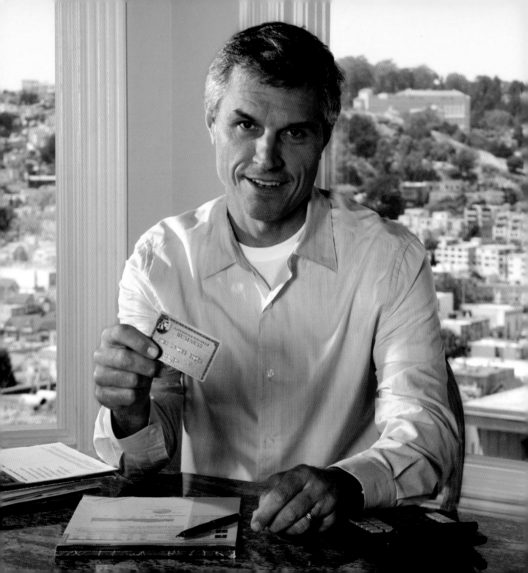

No, I'm serious, we've saved *way too much* for retirement. Take the card, go out, and buy **anything you want.**

I got you dinner with
Harrison Ford
and **George Clooney**
at the charity auction.

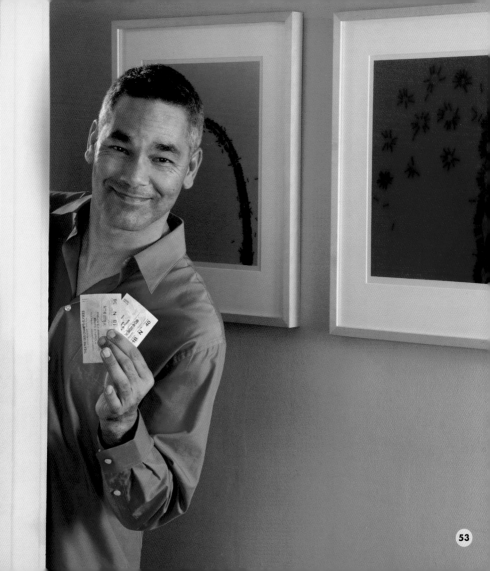

As I suspected

it's reading 10 pounds high.

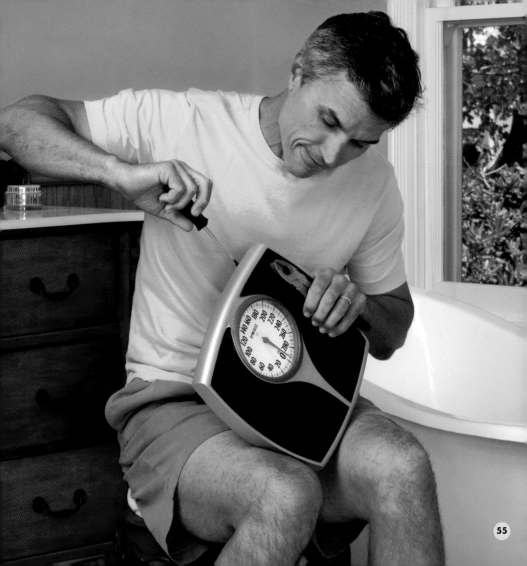

You know,
we can easily afford it.
Why don't we just
**book a suite of rooms
at a hotel**
for when the kids
come with the little ones?

No, **I** must have

put your glasses

in the fridge…

you **never**

misplace things.

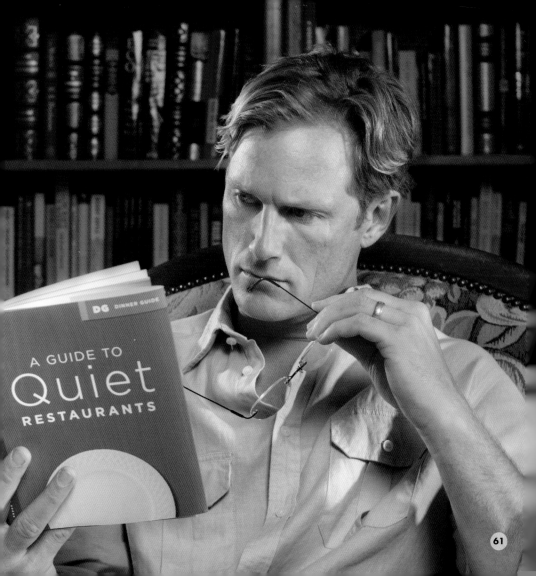

A GUIDE TO
Quiet
RESTAURANTS

DG DINNER GUIDE

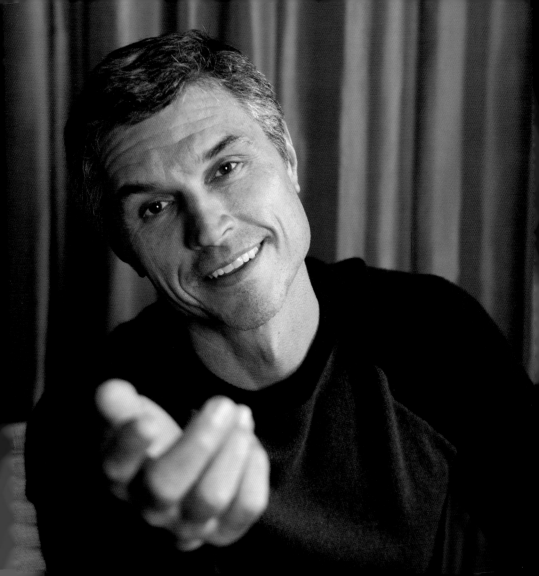

I just **love** the

sparkle

the **silver** puts
in your hair.

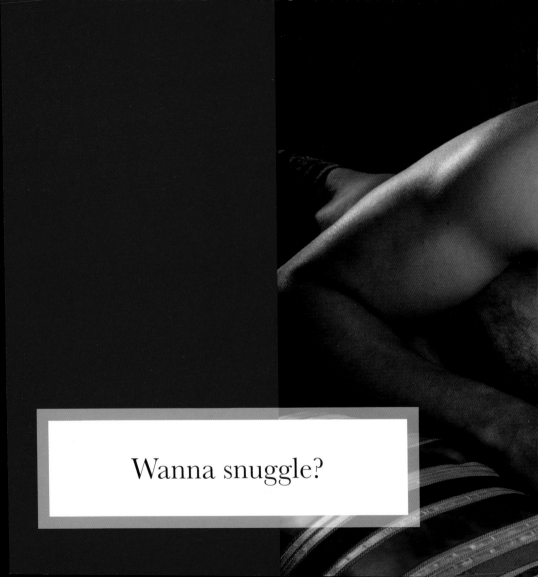

Wanna snuggle?

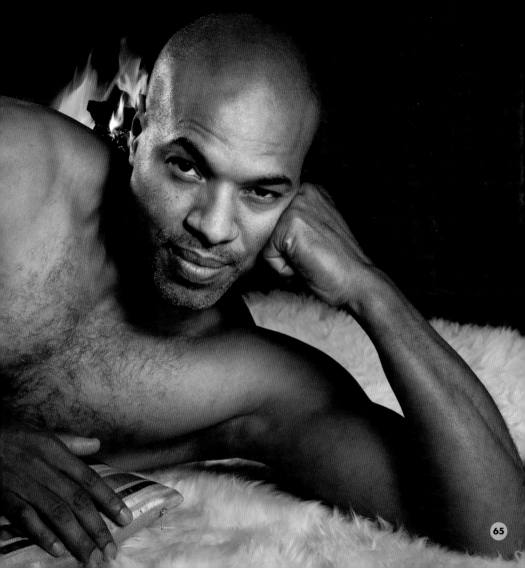

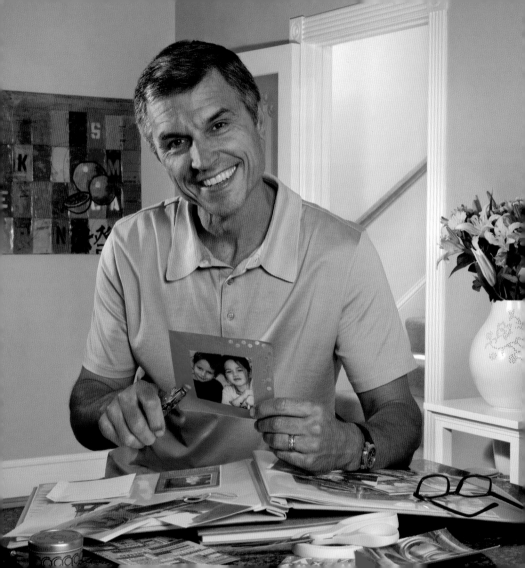

I love scrapbooking with you.

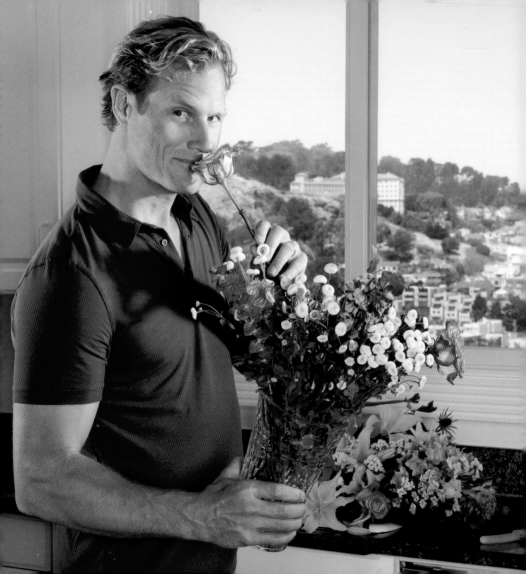

I don't think

the house looks right

unless there are

fresh flowers

around.

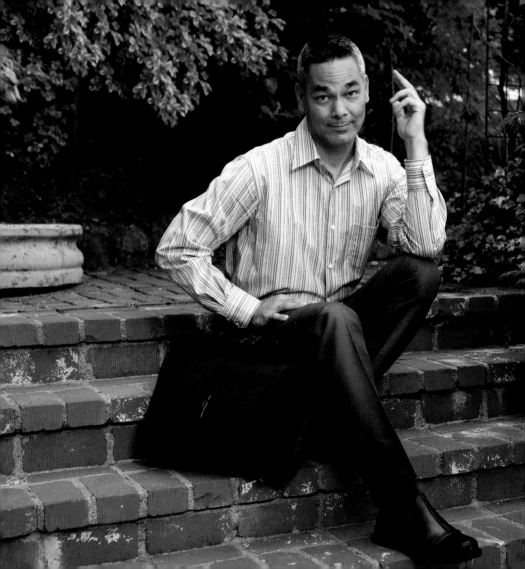

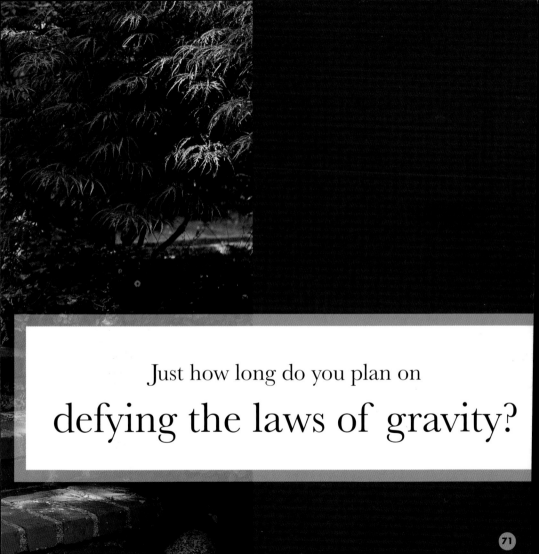

Just how long do you plan on
defying the laws of gravity?

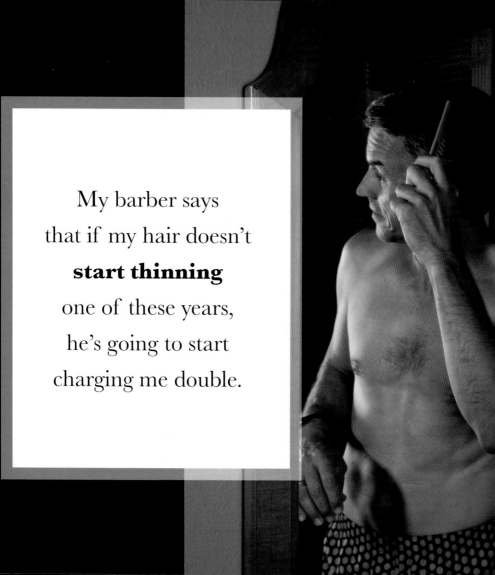

My barber says
that if my hair doesn't
start thinning
one of these years,
he's going to start
charging me double.

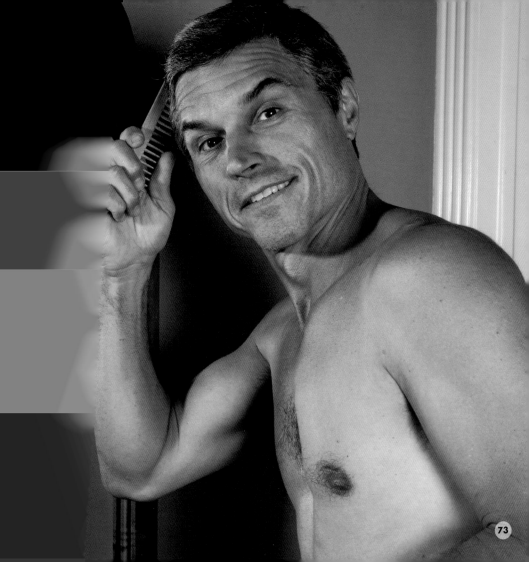

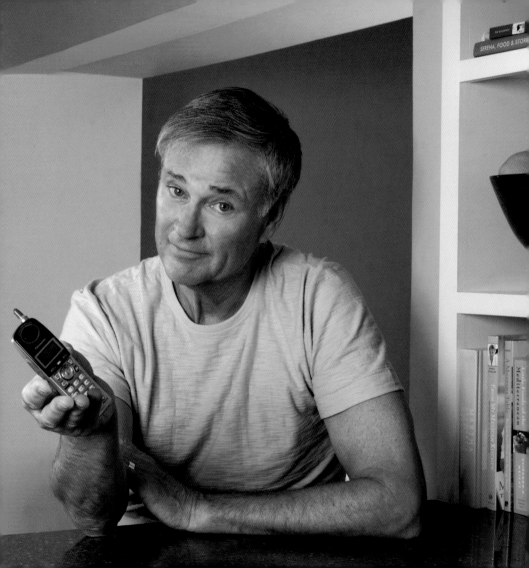

They refuse to go to bed
until they get to talk to you.

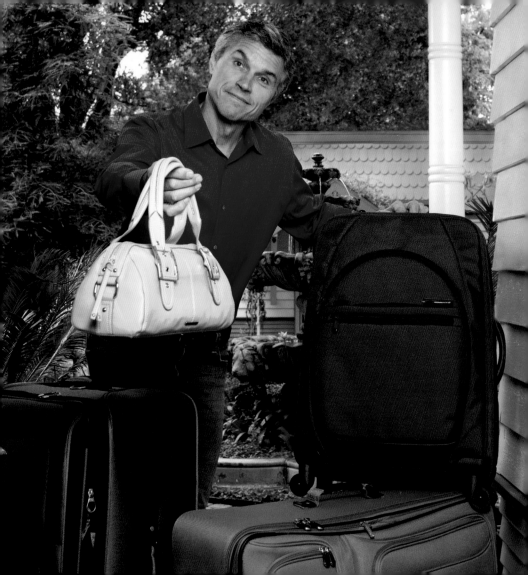

You take the yellow one.

I'll get the rest.

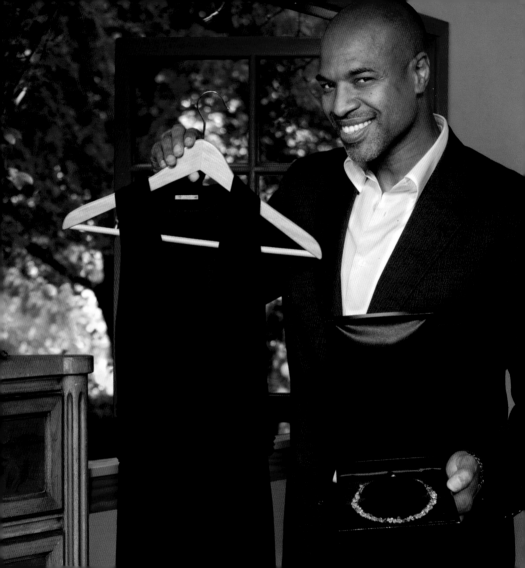

I had to book
three months
in advance
and it's four-star,
so I thought you'd want to
dress up
for the occasion.

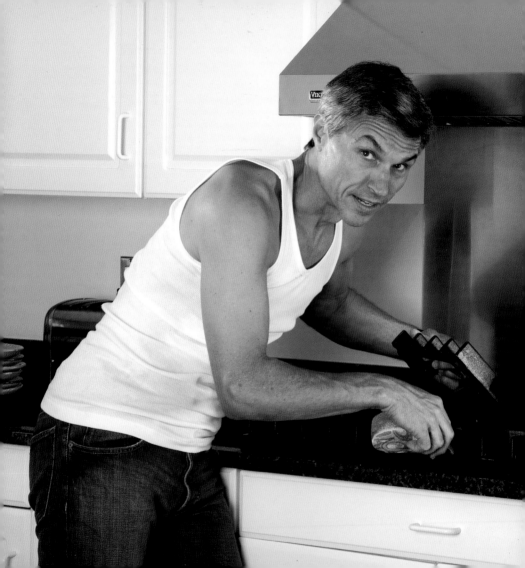

You've done this stuff for **much too long,** it's **my turn** from now on.

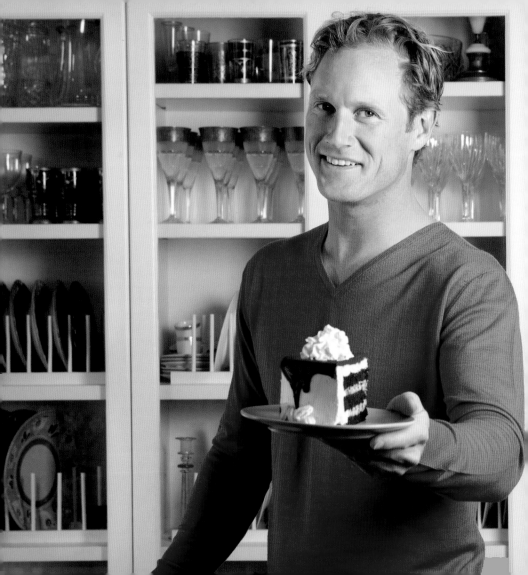

Come on,
have another.
I don't like to see you
denying yourself.

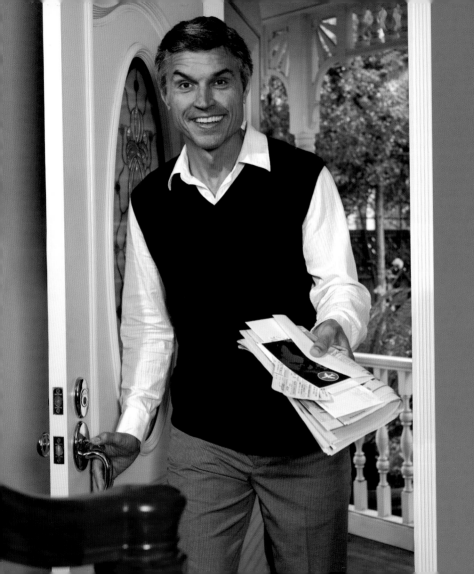

Look! It's
another
'round-the-world trip
from the kids.

Eighty dollars for moisturizer?

Really?

Well, **something** sure is making you look

beautiful.

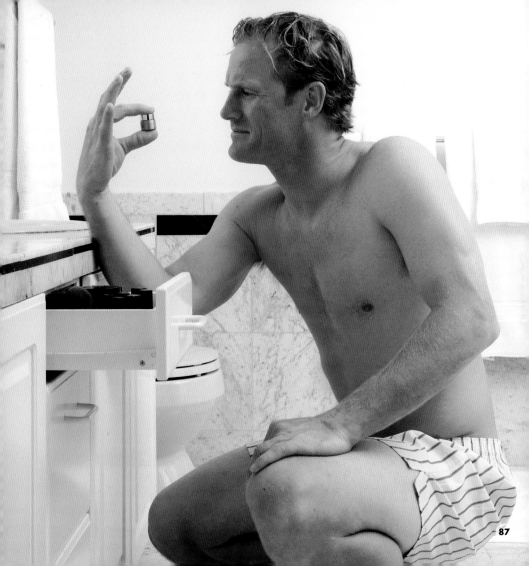

Are you getting the **porn** you deserve?

When you're experiencing hot flashes, does he . . .
A. Offer you a cool towel and a neck rub?
B. Say it's fine to turn down the thermostat if you go and grab him a sweater?
C. Toss you a package of frozen burger patties and say, "Here, make yourself useful. Defrost these"?

When you're thumbing through old photo albums, does he . . .
A. Get wistful about all the great times you've had together?
B. Get wistful about how quickly time is passing?
C. Get wistful about how hot your body used to be?

When you suggest that it's time he trim his ear hair, does he . . .
A. Head right to the bathroom to take care of it?
B. Complain about it being the only hair he has that's still growing?
C. Explain that he's growing it out so he can do a comb-over?

When he comes home smiling and holding a pair of tickets, are they most likely to be for . . .

A. A hot Broadway show, to be followed by a five-star dinner?

B. A new movie starring Charlize Theron?

C. Expired parking meters in front of the adult book store?

When you ask how your 401(k) is doing, does he say . . .

A. "I keep telling you, you can stop working anytime you want to"?

B. "Gee. I thought you were paying attention to the 401(k)"?

C. "Funny you should ask. I was just wondering when that nice Nigerian e-mailer was going to get back in touch"?

When you mention your feet are cold in bed, does he . . .

A. Offer to rub them until they're warm?

B. Remind you there's an extra blanket in the closet?

C. Say, "Geez, with the size of those things, you'd think they'd have their own atmospheres"?"

When you express frustration over the gray in your hair, does he . . .

A. Run his fingers through your silky locks and say he thinks it looks sexy and fabulous?

B. Tell you he thinks you look great, but adds that, of course, he'd be fine with it if you wanted to color your hair?

C. Say, "Yeah, I notice it's been falling out, too"?

At your college reunion, does he . . .

A. Whisper that he can't believe he's the lucky guy who ended up with you?

B. Whisper to your college boyfriend, "Boy, pal, you really missed out"?

C. Whisper to your college boyfriend, "Boy, pal, you really dodged a bullet"?

When you remind him that next month is a special anniversary for you, does he . . .

A. Demurely comment, "It's all taken care of. Just make sure you keep that whole weekend free"?

B. Get wide-eyed and say he's grateful for the reminder, and he'll get right on it?

C. Get wide-eyed and say, "That's not the weekend the Yankees are in town, is it?"

When you complain about the effects of gravity on your body, does he . . .

A. Dismiss your comment and say, "To me, you look better now than you ever did. Don't be ridiculous"?

B. Say, "Don't worry about it, it happens to all of us"?

C. Say, "That's not gravity, babe. That's all those bonbons"?

When you ask if he wants to try couples yoga, does he . . .

A. Say he was thinking the same thing and offer to sign you both up for class?

B. Ask if there might be any younger couples in the class?

C. Bend over and offer to show you his "Full Moon, Skyward" pose?

When you speculate about your odds of having grandchildren, does he . . .

A. Smile warmly, pull you close, look into your eyes, and whisper, "I'd love to be a grandparent with you"?
B. Say, "Are we that old already?"
C. Look alarmed and say, "Do you have any idea what all those extra birthday presents are going to cost?"

When you walk by a guy with an obvious trophy wife, does he . . .

A. Shake his head in contempt at such shallowness?
B. Glance discreetly, and then look embarrassed when he sees you caught him?
C. Shout "Dude!" and high five the guy?

A: 3 points
B: 1 point
C: -3 points

15–30: He's your man! Lock him in.

1–15: Be sure to describe him as your *"friend"* in social situations, to keep options open.

-30–0: You may not be around forever, but it's going to **seem** like forever with this guy. Dump him.

A

AARP, 42-43
Age-appropriate attitude, 10-11, 12-13, 62-63
Appliance repair, 54-55
Appreciation, 16-17, 20-21, 34-35, 86-87

B

Bag carrying, 76-77
Bed warming 36-37

C

Cake, 82-83
Charity auction, 52-53
Cleaning, 80-81
Clooney, George, 52-53
Compliments, 12-13, 17-18, 20-21, 34-35, 62-63, 70-71, 86-87
Communication, 48-49
Compromising, 14-15
Cooking, 26-27
Culpability, 58-59

D

Décor, 44-45
Dining, 26-27, 60-61
Doctor, sexy, 9
Dress up, 78-79

F

Facelift, 34-35
Fanning, 22-23
Flexibility, 42-43
Flower show, 28-29
Flowers, fresh, 68-69
Financial stability, 56-57
Fitness, 42-43, 46-47
Ford, Harrison 52-53

G

Gardening, 32-33
Generosity, 50-51
Gifts, 18-19, 78-79
Glasses, finding, 58-59
Gold Card, 50-51
Grooming, 24-25, 72-73

H

Hair, thick 72-73
Handyman, 55
Hawaii, 14-15
Hot flash, 22-23
Hotel, 56-57

I

Indulgence, 82-83

J

Jealousy, 46-47

L

Luggage, carrying 76-77

M

Moisturizer, 87
Muscles, 46

P

Pillows, throw, 44-45
Plants, 32-33
Property ownership, 14-15
Prostate, small, 38-39

R

Restaurants, quiet, 61
Retirement, 50-51

S

Scale, broken, 55
Scrapbooking, 66-67
Shopping, 50-51
Shopping for, 18-19
Silky robe, 18-19
Silver, hair, 62-63
Snoring abatement, 30-31
Snuggling, 64-65

T

Talk, 48-49
Thoughtfulness, 40-41, 68-69
Throw pillows, 44-45
Travel, 84-85

W

Weeding, 32-33
Weight lifting, 46-47

Y

Yoga, 42-43
Youth, eternal, 16-17, 20-21

Finding out **what women really want**, and getting that information into the public domain, has been the life's work of the Cambridge Women's Pornography Cooperative. Please help support our important scientific breakthroughs by sharing these findings with friends, neighbors, and colleagues.

Go to our Web site, www.wannasnuggle.com, to see, and e-mail, results from the original *Porn for Women* and *XXX Porn for Women: Hotter, Hunkier, and more Helpful around the House!,* as well as our groundbreaking *Porn for New Moms.* You can also buy our journals, postcards, and pinup *Porn for Women* calendars!

Were you **inspired by these photos** to come up with a Porn for Women scenario of your own? Send it to us. We may include it in a future study, and maybe it'll even get published someday. That'll make you an honorary member of the Cambridge Women's Pornography Cooperative.

I just **don't get** this whole *trophy wife* thing.